BP PORTRAIT AWARD 2004

BP PORTRAIT AWARD 2004

National Portrait Gallery

Published in Great Britain by
National Portrait Gallery Publications,
National Portrait Gallery,
St Martin's Place, London WC2H 0HE

Published to accompany
the BP Portrait Award 2004,
held at the National Portrait Gallery, London,
from 17 June to 19 September 2004,
Royal Albert Memorial Museum, Exeter,
from 2 October to 13 November 2004,
Aberdeen Art Gallery, Aberdeen,
from 4 December 2004 to 22 January 2005,
and at the Royal West of England Academy,
Bristol, from 27 February to 26 March 2005.

For a complete catalogue of current
publications please write to the address above,
or visit our website at www.npg.org.uk

ISBN 1 85514 344 5

A catalogue record for this book
is available from the British Library.

Publishing Manager: Celia Joicey
Editor: Caroline Brooke Johnson
Design: Anne Sørensen
Production Manager: Ruth Müller-Wirth
Photography: Prudence Cuming
Printed and bound by St Ives Westerham Press

The publisher would like to thank
the copyright holders for granting
permission to reproduce works
illustrated in this book. Every effort
has been made to contact the holders
of copyright material, and any
omissions will be corrected in
future editions if the publisher
is notified in writing.

Cover: *Caroline* by James Crowther

PREFACE

Judging the 2004 Portrait Award was a compelling process for those on the jury. Confronted with a record number of 955 entries, we needed to debate and refine first a selection of fifty or so works for the exhibition, then just four for the shortlist and finally just one overall winner. When the portraits were laid out for viewing all sorts of people were present – a closely detailed study of a friend; the loose, but wonderfully painted figure of a parent; a child with a sulky smile; a close reading of three friends; a serious-looking self-portrait with eyes fixing us closely – so many competing claims made visible. The great majority of those portrayed were strangers to us, met for the first time in the judging rooms. But in so many of these images the effort and craft in the execution have combined to produce a vivid portrayal, a sense of being introduced by a friend to someone new, an encounter enacted through the brushstrokes and the composition.

The ways in which portraits engage us are also compelling. In a digital and multimedia age there may be an even greater need to have a slow and multi-layered process such as painting to be the means to see ourselves and others. And on the evidence of the Award there is no lack of artists to take up the challenge, and I hope that once again a large number of visitors will enjoy the results.

SANDY NAIRNE
Director, National Portrait Gallery

FOREWORD

BP recognises the role that arts and culture play in the economic and social fabric of the country. We maintain a focus on excellence and our social investment programme includes support for some of Britain's most outstanding cultural institutions, including the National Portrait Gallery.

It is now twenty-four years since the Portrait Award was established, and fourteen years since BP became involved. Over the years the growth in the number of entrants, from across the United Kingdom and abroad, and in the number of visitors to the exhibition, is very encouraging. I believe the Award continues to demonstrate the tremendous value and quality of modern portraiture.

BP is delighted to be associated with the Award and very happy to be able to continue our partnership with the National Portrait Gallery. The skill and commitment of the Gallery's staff have turned what began as a small and experimental project into a sustained, internationally recognised success. Our thanks are due to them and, of course, to the artists whose ability to capture human character on a two-dimensional canvas is a rare and precious quality.

LORD BROWNE OF MADINGLEY
Group Chief Executive, BP

Hans Memling's *Portrait of a Man* shows a young man, brown eyed, dark haired, sombrely dressed, against a tapering blue sky. A flattish landscape spreads out behind him (fields, trees, a lake, a church, a tower, a hint of distant hills) and it could be he has some stake in it. But he looks more like a traveller than a landowner – the cloak he carries over his right shoulder suggests he has been intercepted in the course of walking somewhere. There's a sense of purpose about him, but the purpose isn't specified – nor are his name, age, status, mood and character. I could read up on Hans Memling, and study the iconography of fifteenth-century Flemish painting, and explore its links with Italian art of the same period. But I'm not sure that would help me know the young man any better, or that I *want* to know him any better, or that *he* would want it. The painting presents him in intimate detail – we can see every hair, including the stubble on his chin. Yet it also keeps him at a distance. He's recognisable and unknowable at the same time.

What I like about the painting, I realise, is its subject's apparent indifference to how he's being perceived or represented. He looks to the side, absorbed in thought, not engaging with the painter. Self-possession of this kind isn't unusual in portraiture; some of Hans Holbein the Younger's sitters have it too. But more commonly the subjects stare directly out, shy, proud, haughty or self-conscious, in their best clothes or on their best behaviour, encircled by pets or worldly possessions, confident of our respect or eager for our approval. They're looking at us, the viewer, but also, more intimidatingly, at the painter, daring him to find fault; the look reminds us that a transaction is involved – that the portrait, more than likely, has been commissioned and that the painter, if he wants his money, will have to deliver the goods. Memling's young man doesn't seem to be part of any such contract, or to know that he's being painted at all. And though this may be an illusion, it's clearly one that Memling intended. We're meant to forget the painter, with his brushes and his purse, and concentrate on the face of the subject.

I find it odd to be haunted by a five-hundred-year-

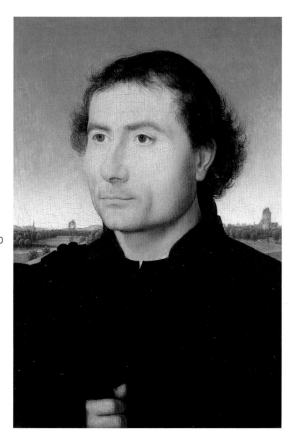

PORTRAIT OF A MAN
Hans Memling, *c*.1470
Oil on panel,
335 x 232mm
(13¹⁄₈ x 9¹⁄₈")
The Frick Collection,
New York

old portrait. But others will know the feeling. It might be Jan van Eyck's *Arnolfini Marriage*, El Greco's *St Jerome* or Rembrandt van Rijn's *Girl at a Window*: the faces gaze out from another century, and it's not just that (as people often say) 'their eyes follow you round the room' but that their lips might tell fascinating stories, if only able to speak. Sometimes we make up stories for them. Or novelists like Tracey Chevalier (*Girl with a Pearl Earring*) and Deborah Moggach (*Tulip Fever*) do it on our behalf. Or art historians furnish the real-life facts, and explain the significance of such and such an item of jewellery, or point out some symbol (that skull,

look, under the table), which we might otherwise have missed. Yet no amount of information, real or speculative, is ever enough. We come back to those faces and, as with the faces of people we meet in life, try to fathom what's going on beneath the skin.

'There's no art to find the mind's construction in the face,' Duncan says in *Macbeth*. Portraitists acknowledge the truth of that but also fight against it. If they were cartoonists, they could use thought bubbles to spell out what's on their subjects' minds. If they were paparazzi, editors would supply tell-tale captions for their photos ('A distraught Posh Spice, devastated by news of her husband's alleged affair, seen leaving for Spain yesterday'). Painters can't resort to such methods. Their official duty lies in rendering outward appearance. But their hope – the other agenda – is to unlock the door to the inner life.

Portraits are often compared with biographies for this reason. But the analogy doesn't quite work. Biographies journey through time, following the soul (to quote Edmund Gosse) 'in its adventures through life', whereas portraits are fixed in time and space. In that sense they're more like poems, offering an intellectual and emotional complex in an instant of time. Their angle of vision is selective – usually head and shoulders, rather than head-to-toe – but its intensity can be more exposing than a full-length nude would be. Like poems, portraits have to make an impact at a single glance but also repay closer examination, so that even at a hundredth look they're inexhaustible.

The complexity of the task no doubt explains why portrait painting has survived as long as it has. It was supposed to have died a century ago and the obituaries have been appearing ever since. First photography usurped it, then modernism smashed it to pieces, then abstract expressionism rendered it meaningless, and now installation and video art have finished it off – so the story goes. Yet the patient looks remarkably healthy: eyes, nose, ears, lips, skin, all faculties intact. As with other deaths (the death of the novel, the death of documentary film, the death of

figurative painting as a whole), the death of the portrait has been much exaggerated.

The key to its longevity is its promise to tell the truth. What the subject asks, the viewer expects and the painter undertakes to deliver is a likeness. Giorgio Vasari said of Raphael's *Pope Julius II* that it was 'so true and so life-like, that the portrait caused all who saw it to tremble, as if it had been the living man'. The truest art is the most feigning of reality and the best portraits counterfeit reality so persuasively that instead of pigment we see flesh. Lucian Freud's paintings do this; so do Ron Mueck's sculptures; so did Charlotte Harris's prize-winning entry in last year's BP Portrait Award. With other forms of painting there's a licence to invent, but portraits are meant to be non-fictional. That's the constraint they labour under – and also their greatest strength.

Likeness isn't enough; there has to be life as well. Roger Fry complained of one of John Singer Sargent's paintings, 'I cannot see the man for the likeness'. When I worked as a literary editor on a national newspaper, I'd sometimes commission drawings of writers to accompany book reviews. There was one illustrator who caught resemblance perfectly, but his writers always looked funereal, like monuments of themselves. Photo-realism can be similarly deadening – when you're not in the mood, so can Bill Viola's saintly slo-mo. There has to be some spirit to the work. Which doesn't mean making the sitter look spiritual or soulful, but does mean catching some of the inner energy – flickers of feeling, shadows of thought, or what Leonardo da Vinci called 'the motions of the mind'.

The moment that painters began to portray individuals rather than types is a watershed in the history of art. Most critics locate the breakthrough in Renaissance Italy with Paolo Uccello, Tommaso Masaccio, Sandro Botticelli and so on; for them, capturing likeness was no longer seen as heresy but as an act of homage to God's creation. The more particular a face is, they realised (the tilt of that nose, the jut of that chin), the more universal. What we respond to in Renaissance portraits is partly this sense of the other

faces, from other times and places, which they contain. The generalised types in medieval painting are far less recognisable.

Recognition is a tricky business. With most portraits, the originals aren't known to us, because unfamous and/or long-dead. So how do we feel able to pontificate (and we do, we do) on their convincingness? The secret lies in their attention to minutiae. If an artist takes care with tiny detail – eyelashes, finger-hair, wrinkles, flushes, bruises – we trust him or her to have got the bigger picture right, the line of a head or shape of a body. We have Erasmus's word for it (in a letter to Thomas More) that Hans Holbein the Younger's depiction of More 'is so completely successful that I should scarcely be able to see you better if I were with you'. But even if we didn't have this testimony, we might guess as much, because of Holbein's loving attentiveness to the loose thread dangling from More's hat. That eye for detail is what gives a portrait its authority.

A sense of authority is equally important when we *do* know the subject of a portrait, either in person or through photographs. The Michael Frayn portrayed by Jennifer McRae in the Gallery's recent commission isn't Michael Frayn as I picture him: the hair is whiter, the mouth more grimly set, the pose more dandyish, the sense of assurance more marked than in life. But I don't look at the painting to have my opinions confirmed, but for new insights, and I like the emphasis on Frayn's intellectual stature: he stands tall, and his hair blends into the sky, suggesting someone unworldly, with his head-in-the-clouds – a quality I'm willing to believe is there. Portraitists can't invent but they do have to interpret, otherwise they're no better than paparazzi. A replication of existing images leaves the person behind the icon uncaptured – a point Andy Warhol made when he depicted Marilyn Monroe as an assemblage of fifty identical images, none more authentically Marilyn than the next.

Authenticity – the contract to be truthful – is crucial to portrait painting. Yet some critics deny its importance. Portraits are designed only to flatter, they say, and it's best to regard them as a necessary evil, the

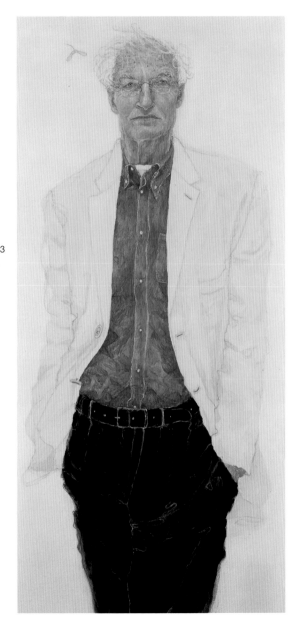

MICHAEL FRAYN
b.1933 (detail)
Jennifer McRae, 2003
Oil on canvas,
1525 x 636mm
(60 x 25")
National Portrait
Gallery (NPG 6647)

equivalent of hack journalism, while the real work, unwilled, goes on elsewhere. Besides, they add, every portrait is highly subjective and therefore, in effect, a self-portrait, a point succinctly made by a Charles Addams *New Yorker* cartoon which shows an artist sitting at his easel in a landscape of mountainous grandeur and painting his own face. But surely the challenge of portraiture is its demand for self-effacement. With a model, artists can make up whatever story they like. With a sitter, especially a famous one whose story is already well known, there's no such room for fabrication. This constraint can be liberating. At worst, the artist indulges the subject. But the task of producing a likeness can also stop him indulging himself.

Success depends on a balance of power. If the artist is over-imposing, the subject will seem marginalised, negligible, a mere addition to the oeuvre; and if the sitter calls the tune, the result will be hagiography. But not all artists are monsters of egotism and not all sitters expect to be pampered. Thomas Carlyle told James Whistler to 'fire away, man'. And Oliver Cromwell was happy for Peter Lely to paint him 'warts and all'. Where truth to life is the mutual goal, the result can be creative collaboration rather than stale compromise.

The dynamics of the artist–model relationship have been explored many times and the standard motifs are well known: power, status, beauty, sexual attraction, exploitation. Artist–sitter relationships, which are more like brief flings than deep love affairs, haven't been documented to the same extent. When I asked Paula Rego about the experience of painting Germaine Greer, she admitted to having felt 'under enormous pressure'. 'It's a terrific responsibility to have to do someone justice, and I felt in a state of panic, because I'm not a portrait painter and was worried I wouldn't have the knack.' Greer sat for her over six sessions of two hours, listening to Wagner, which relaxed her and also freed Rego – 'you don't want to be worrying about your subject's well-being, and I can't concentrate if I have to speak.' At first they tried a pose with Greer reading from a book, but eventually they happened on a better

position, with Greer sitting on a low sofa: her legs are open, her hands are in her lap, she wears a red dress and she's looking down and to the side. The worn shoes, with their gaping mouths, were 'very important', Rego says, 'and so were her hands, because Germaine gardens a lot, and they're gardener's hands – to me her being a writer wasn't crucial, but she did have to *look* like her.'

Portraiture, Rego says, is about 'observation, not interpretation – you don't emote, you just look; and what's marvellous is that it's not about you at all.' Her description of the process is wonderfully practical: 'Did I try to capture something beyond the likeness? No, to me the likeness is the beyond: if you get the look (nose, shape of head, shoulders, etc.) you get the spirit as well.' Despite the pragmatism, there is something magical in Rego's account of the 'gotcha' moment: 'I was in despair. Germaine has a very mobile and expressive face, with lots going on, which was very hard to pin down. I'd obliterated so much. But then suddenly I hooked in – I was working with pastels, which can be a bit like using a pencil, and the pastel took on a life of its own, and I thought "I can't believe this – I hope, I hope", and she was there.'

To Greer, what mattered was that the portrait should '*feel* like' her; to Rego, it had to *look* like her. Both seem to have been happy that, in the end, 'justice' was done. Not all such transactions turn out so well. John Singer Sargent's *Madame X* outraged the family of its subject, Madame Pierre Gautreau, because it showed her *décolletée* and with a slipped-off shoulder strap. The family demanded Sargent withdraw the work from the Paris Salon. He refused but later, as a compromise, repainted the strap. At least Sargent had some choice in the matter. The codpiece in Agnolo Bronzino's portrait of a young Medici aristocrat called Lodovico Capponi was painted over in the nineteenth century. Bronzino would not have understood the objection: the codpiece was standard dress; probably the most he meant to assert was his subject's youthful vigour. But a *trompe-l'oeil* made what was pushing up through Capponi's jacket

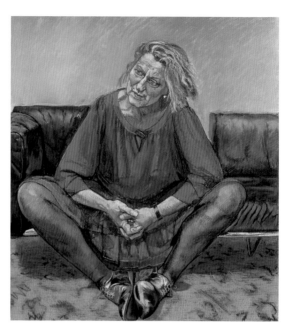

GERMAINE GREER
b.1939
Paula Rego, 1995
Oil on canvas,
1200 x 1111mm
(47¼ x 43¾")
National Portrait
Gallery (NPG 6351)

look like an exposed and erect penis. The codpiece has since been restored, and the painting now hangs in the Frick Collection, where it prompts appraising giggles rather than howls of indignation.

The real potency of Bronzino's portrait isn't that codpiece, though, but our knowledge that Lodovico Capponi exists (or once existed) in the flesh. This assumption of a direct link between the painted image and the human original lies at the heart of all representational art. It's what makes lovers angrily tear up the photos of those who have betrayed them. It's what caused Iraqis to destroy images of Saddam Hussein last year and to inflict on them the violence they'd have liked to inflict on him in person. It's the passion that has driven on artists from Hans Memling to David Hockney to create ever more accurate likenesses. It's why portraits have centuries more life in them yet.

BLAKE MORRISON

16

BP PORTRAIT AWARD 2004

The Portrait Award is an annual event aimed at encouraging young artists, from around the world aged between eighteen and forty, to focus upon and develop the theme of portraiture within their work. Many of the exhibiting artists have gained commissions as a result of the considerable interest aroused by the Portrait Award.

The competition is judged from original paintings in oil, tempera or acrylic, which have been painted from life with the human figure predominant. This year the judges selected fifty-four portraits to exhibit out of a record number of 955 entries.

THE JUDGES

Chair: Sandy Nairne, Director, National Portrait Gallery

Susan Ferleger Brades, Director, Hayward Gallery

John Keane, Artist

Trevor Phillips OBE, Chair, Commission for Racial Equality

Des Violaris, Business Adviser, UK External Affairs, BP

THE PRIZES

The BP Portrait Awards are:

First Prize	£25,000
Second Prize	£6,000
Third Prize	£4,000
Fourth Prize	£2,000
Travel Award	£4,000

PRIZE-WINNING PORTRAITS

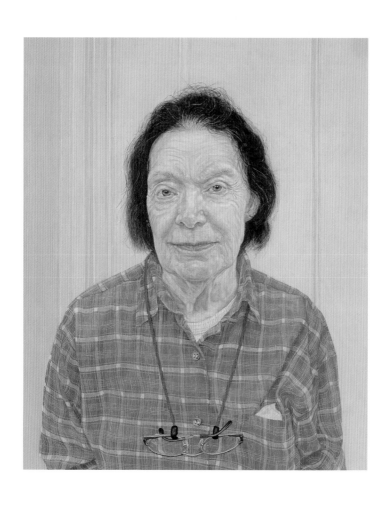

HEAD FULL OF SMILES
Fergus Mayhew
Acrylic and oil on board, 468 x 382mm (18$\frac{1}{2}$ x 15$\frac{1}{8}$")

19

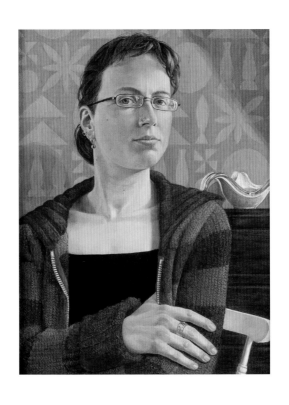

LOUISE TIPLADY
Paul Harris
Oil on canvas, 408 x 310mm (16$^{1}/_{8}$ x 12$^{1}/_{4}$")

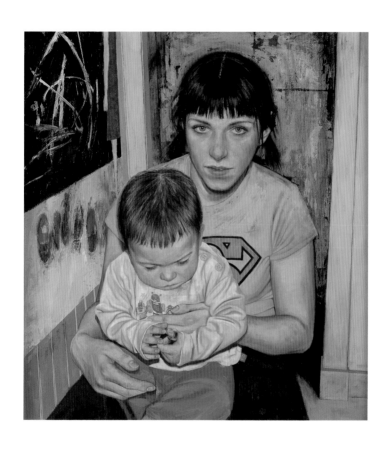

THE MIRACLE
Stephen Shankland
Oil on board, 662 x 612mm (26^1/$_8$ x 24^1/$_8$")

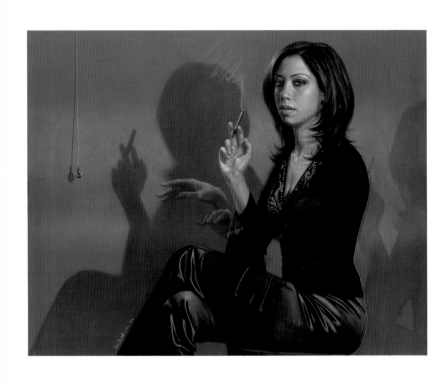

SELF-PORTRAIT
Sara Shamma
Oil on canvas, 1474 x 1152mm (58 x 45³/₈")

22

SELECTED PORTRAITS

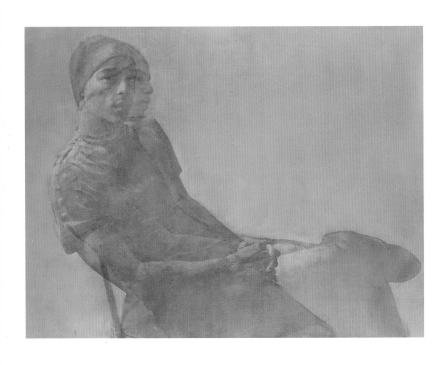

TRACE
Jackie Anderson
Oil on board, 863 x 1154mm (33$^7/_8$ x 45$^3/_8$")

24

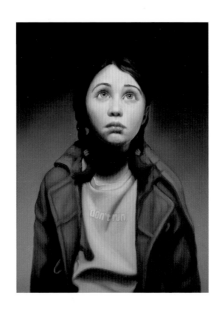

PORTRAIT OF JOSIE
Mary-Jane Ansell
Oil on board, 393 x 292mm (15½ x 11½")

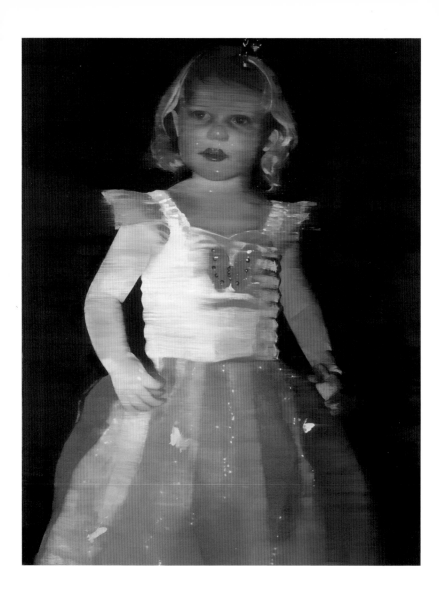

BUTTERFLY
Nicholas Archer
Oil on canvas, 1681 x 1322mm (66$\frac{1}{8}$ x 52$\frac{1}{8}$")

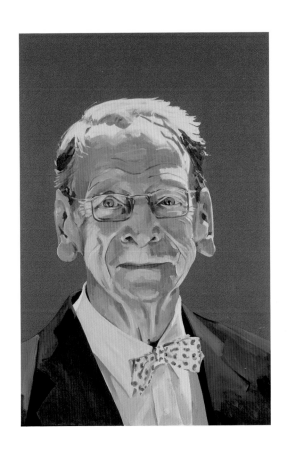

BOMPA (GRANDAD)
Bianca Alice Berends
Oil on canvas, 1504 x 1000mm (59 x 39³/₈")

27

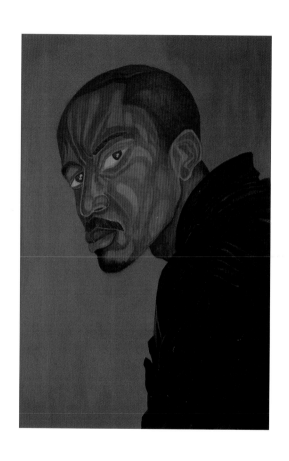

REDEYE JACK JONES
Lanceford Brown
Acrylic on board, 588 x 390mm (23$^{1}/_{8}$ x 15$^{3}/_{8}$")

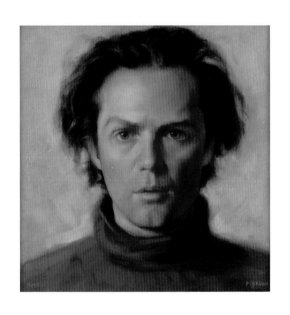

SELF-PORTRAIT
Paul Brown
Oil on panel, 368 x 368mm (14$\frac{1}{2}$ x 14$\frac{1}{2}$")

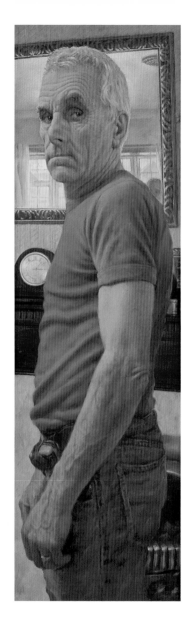

UNTITLED (ARTIST'S FATHER)
Vincent Brown
Acrylic on board, 1210 x 368mm (47⁵/₈ x 14¹/₂")

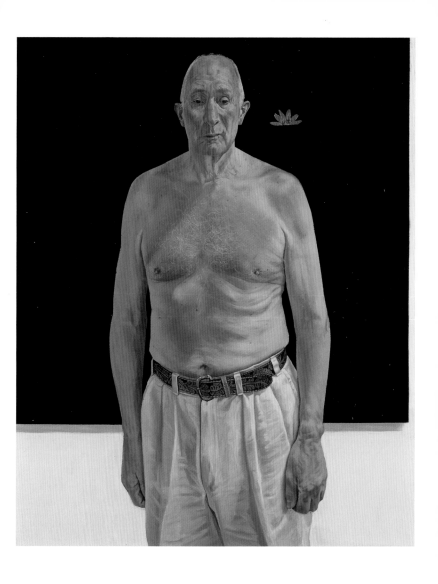

EDDIE II
Jason Butler
Oil on canvas, 1181 x 966mm (46¹/₂ x 38")

31

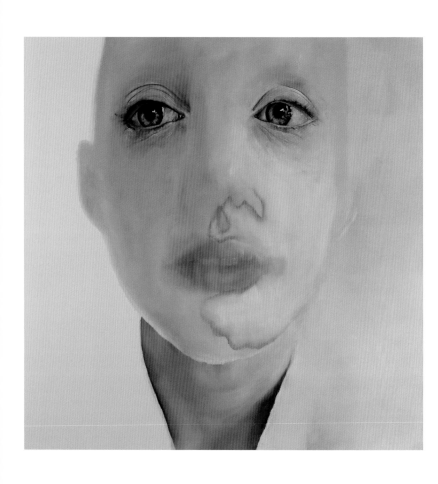

H
Gary Colclough
Oil on canvas, 1494 x 1487mm (58^7/$_8$ x 58^1/$_2$")

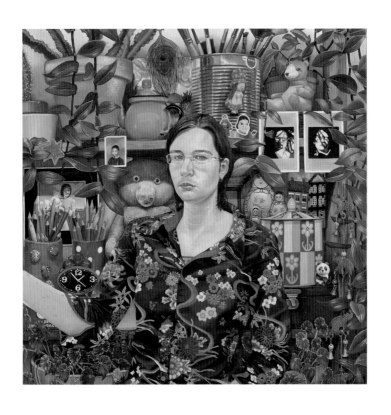

SELF-PORTRAIT
Georgia Cox
Oil on canvas, 598 x 598mm (23$\frac{1}{2}$ x 23$\frac{1}{2}$")

33

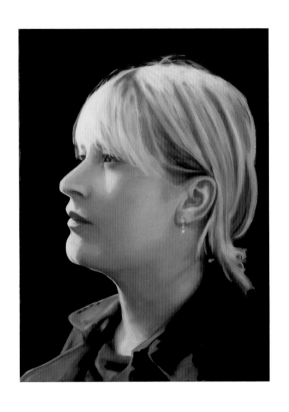

CAROLINE
James Crowther
Oil on canvas, 409 x 307mm (16$\frac{1}{2}$ x 12$\frac{1}{8}$")

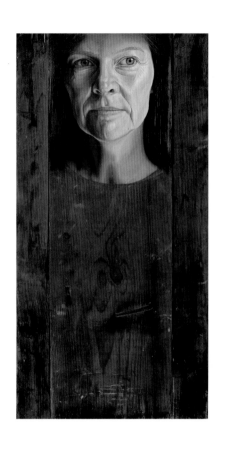

UNTITLED
Sebastian Dacey
Oil on panel, 396 x 204mm (15⁵/₈ x 8")

35

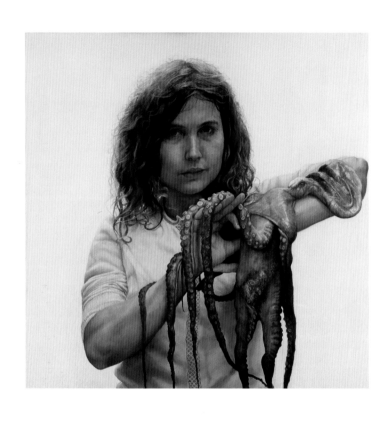

NICOLA WITH OCTOPUS
Joel Ely
Oil on linen, 762 x 762mm (30 x 30")

THREE MEN NAMED IAN
Darvish Fakhr
Oil on board, 152 x 457mm (6 x 18")

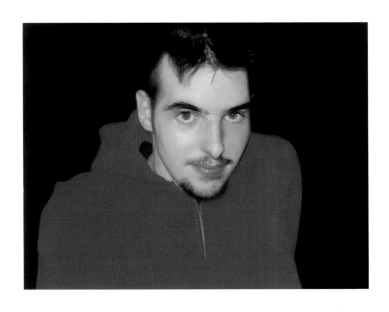

STEVE RYAN
Maryam Foroozanfar
Oil on board, 277 x 353mm (10$^7/_8$ x 13$^7/_8$")

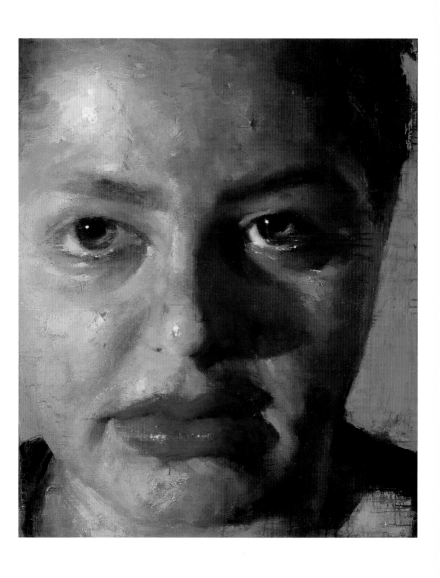

TWENTY-EIGHT DAYS OF VEILED SORROW
Savas Georgiadis
Oil on canvas, 1204 x 1002mm (47³/₈ x 39¹/₂")

39

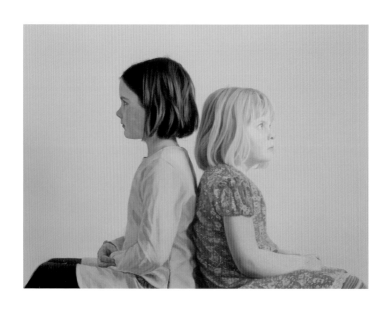

FLORA AND BETTY
Dominique Grantham
Oil on canvas, 560 x 760mm (22 x 30")

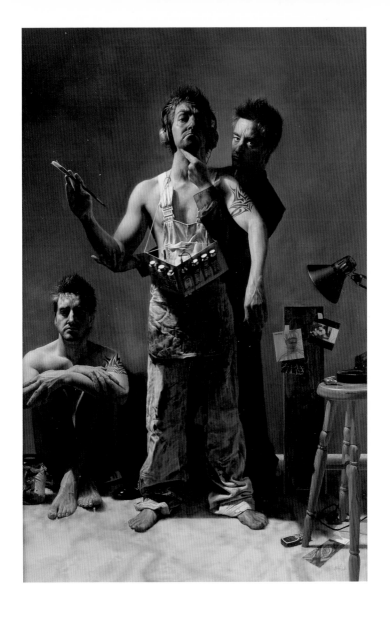

THE ARTIST, THE MODEL AND THE CRITIC
Mitch Griffiths
Oil on canvas, 1897 x 1239mm (74⅝ x 48¾")

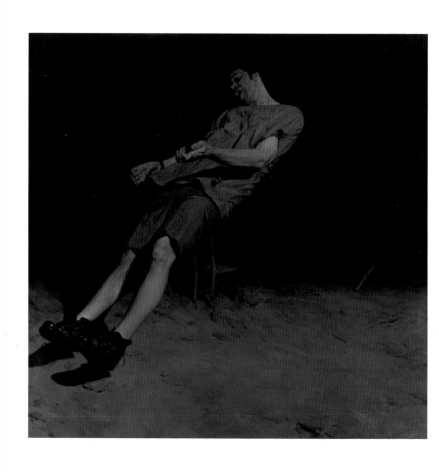

ROBERT SCHNEIDER
Phil Hale
Oil on linen, 1738 x 1779mm (68³/₈ x 70")

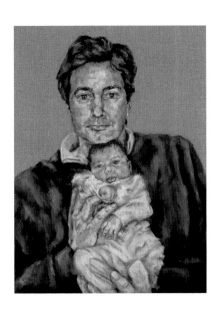

THOMAS FAIRFAX AND FATHER
Gemma Harwood
Oil on canvas, 615 x 458mm (24^{1}/$_{8}$ x 18")

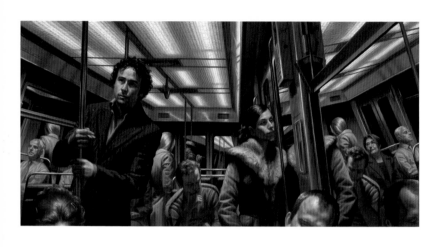

SELF-PORTRAIT IN THE METRO
Ralph Heimans
Oil on canvas, 849 x 1697mm (33^1/$_2$ x 66^7/$_8$")

44

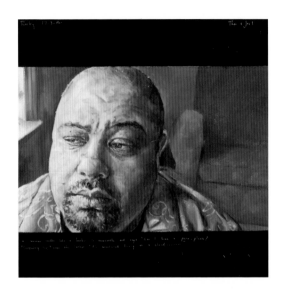

MATT
Jon Jones
Oil on board, 419 x 422mm (16^1/$_2$ x 16^5/$_8$")

45

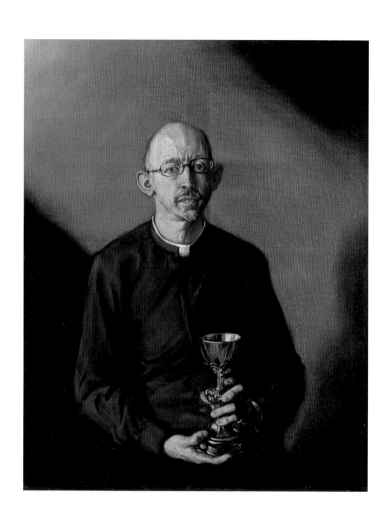

FATHER NICHOLAS CRANFIELD
Paul Lisak
Oil on canvas, 1002 x 813mm (39¹/₂ x 32")

46

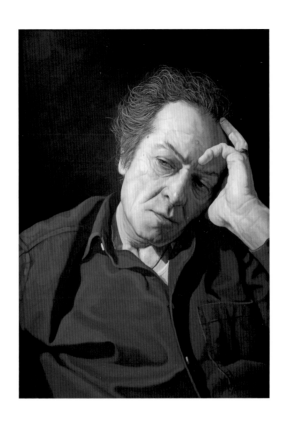

THE UNCLE RINO
Marco Marini
Oil on canvas, 550 x 399mm (21$^5/_8$ x 15$^3/_4$")

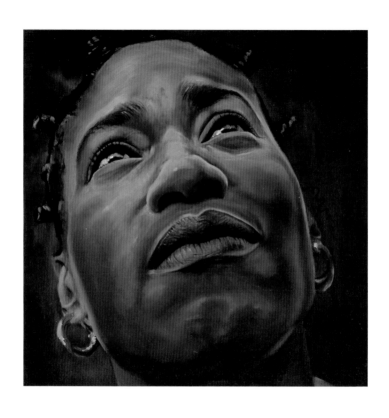

NYANDA
Helen Masacz
Oil on canvas, 598 x 600mm (23^1/$_2$ x 23^5/$_8$")

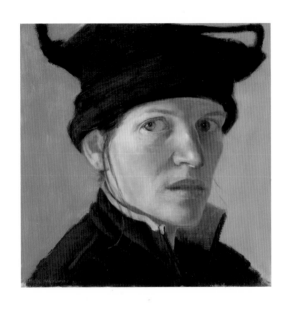

SELF-PORTRAIT
Maeve McCarthy
Oil on panel, 376 x 380mm (14³/₄ x 15")

49

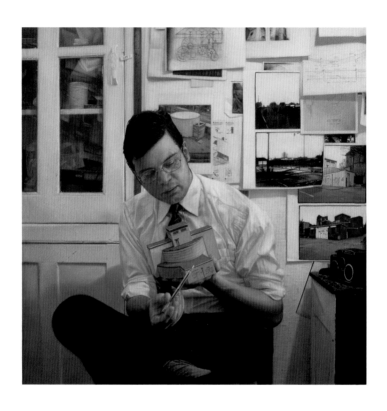

DR MARTIN SKITTLES, ARCHITECTURAL HISTORIAN
Nicholas Middleton
Oil on canvas, 811 x 812mm (31³/₄ x 31⁷/₈")

50

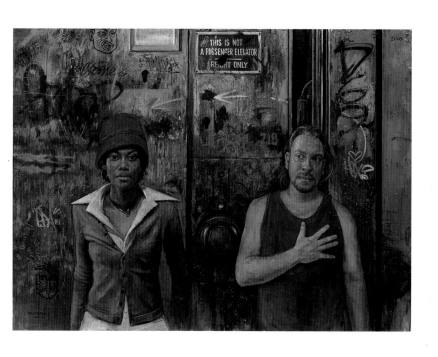

THE ELEVATOR
Tim Okamura
Oil on canvas, 1268 x 1730mm (49⁷/₈ x 68¹/₈")

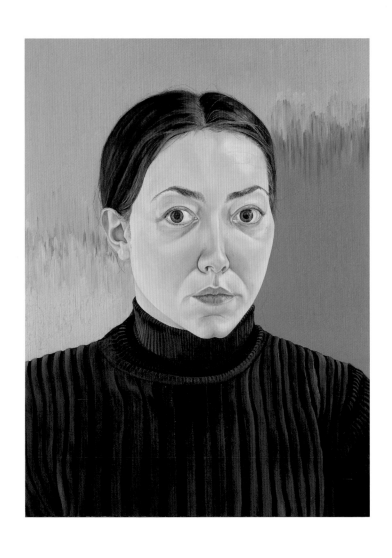

THIS IS ME – SELF-PORTRAIT
Anna Orchard
Oil and acrylic on canvas, 1219 x 916mm (48 x 36")

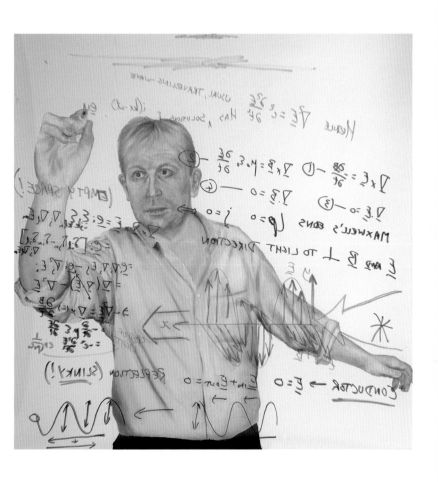

THE OPTICS LESSON OF DOCTOR TURNER
Alan Parker
Mixed media, 1219 x 1219mm (48 x 48")

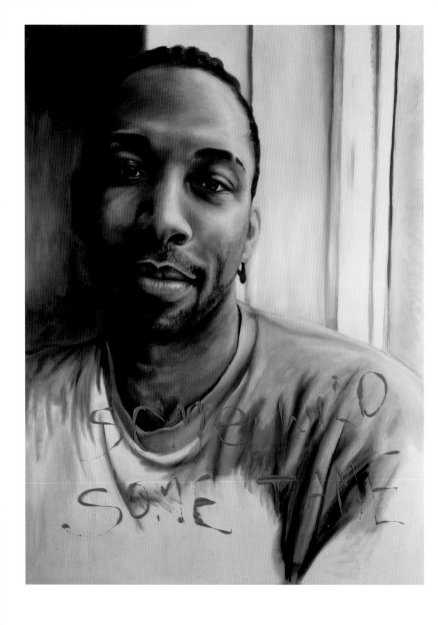

SOME WILD, SOME TAME
Imogen Paton
Oil on board, 1943 x 1440mm (76¹/₂ x 56³/₄")

54

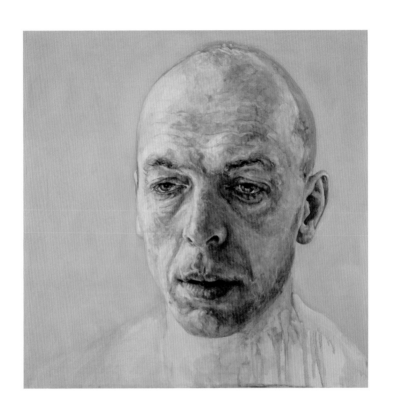

WITNESS
Freya Payne
Oil on canvas, 493 x 493mm (19³/₈ x 19³/₈")

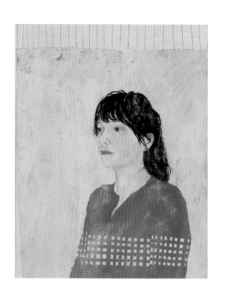

OLIVIA
Robert Proudfoot
Acrylic on board, 387 x 336mm (15$\frac{1}{4}$ x 13$\frac{1}{4}$")

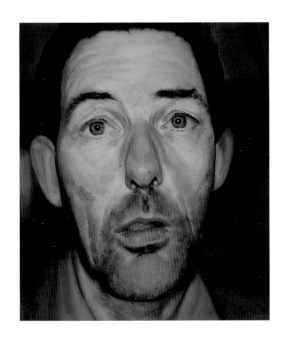

RAYMOND
Patrick Redmond
Oil on canvas, 505 x 442mm (19^{7}/$_{8}$ x 17^{3}/$_{8}$")

GAZE
Philippa Robbins
Oil on board, 190 x 568mm (7$^{1}/_{2}$ x 22$^{3}/_{8}$")

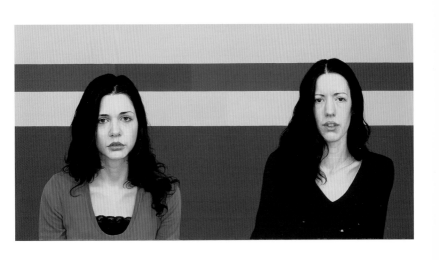

MISS DAVIES
Stephen Rogers
Oil on board, 315 x 609mm (12³/₈ x 24")

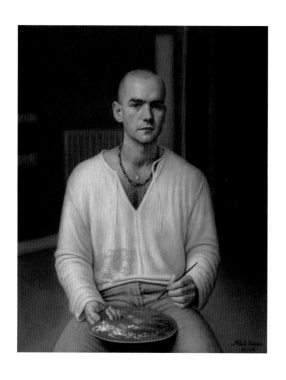

SELF-PORTRAIT
Mark Roscoe
Oil on canvas, 904 x 703mm (35⅝ x 26⅝")

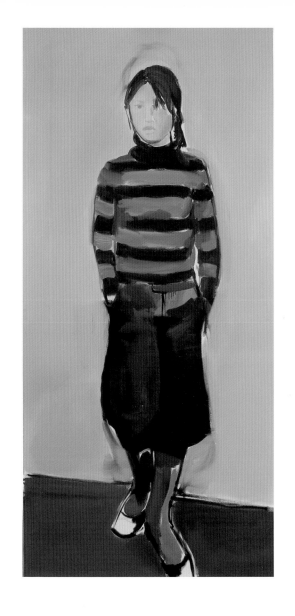

SILIA
Gideon Rubin
Oil on canvas, 1933 x 916mm (76¹/₈ x 36")

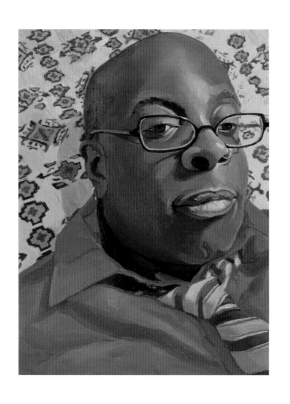

TIFF MY BOI
Teri Sanders
Oil on canvas, 457 x 305mm (18 x 12")

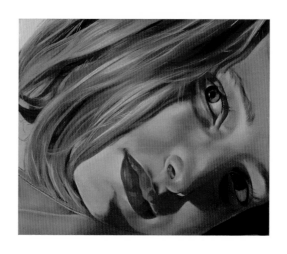

ELLEN
Adria Sartore
Oil on canvas, 298 x 349mm (11³/₄ x 13³/₄")

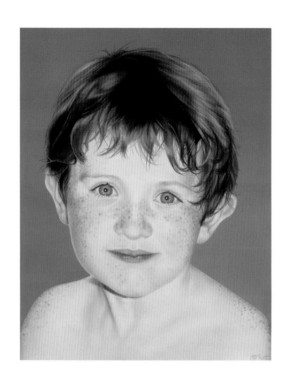

OLIVIER
Nathalie Scott
Oil on canvas, 516 x 405mm (20¼ x 16")

64

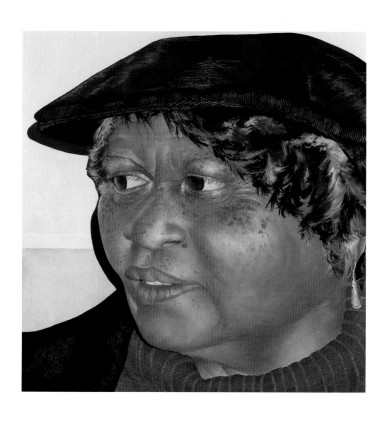

NORMA
Sarah Simpson
Acrylic on canvas, 914 x 915mm (36 x 36")

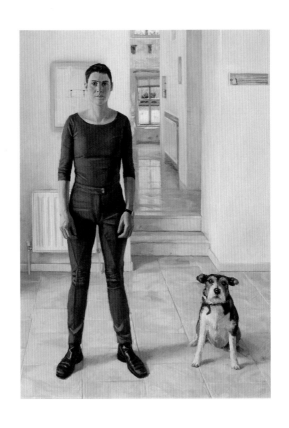

ORLA KELLY AND SPARKY KELLY
(IN SCART, IN THE 'NEW HOME')
Blaise Smith
Oil on panel, 851 x 603mm (33^1/$_2$ x 23^3/$_4$")

66

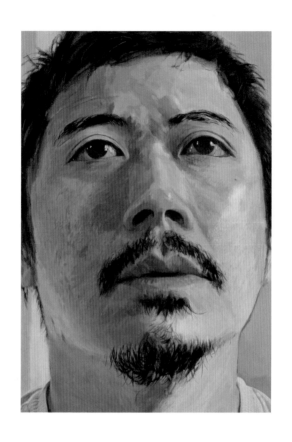

THOMAS
Nigel Spong
Acrylic on canvas, 816 x 559mm (32 x 22")

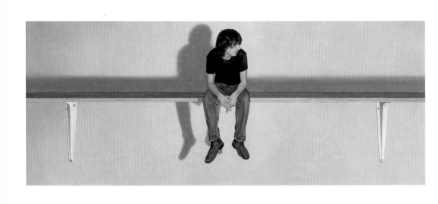

SELF-PORTRAIT
James Stewart
Oil on board, 494 x 1250mm (19^1/$_2$ x 49^1/$_4$")

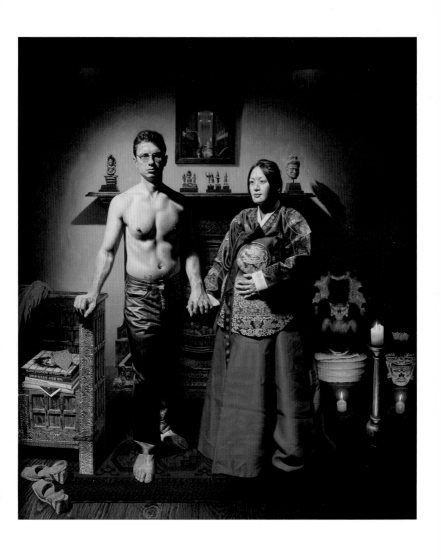

ALEXANDER AND EUN JU
Andrew Tift
Acrylic on canvas, 1127 x 973mm (44³/₈ x 38¹/₄")

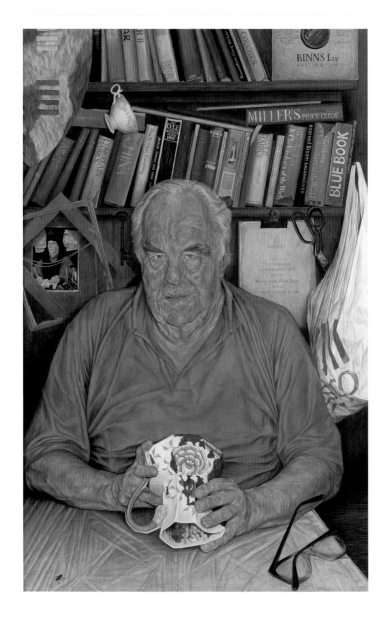

HARRY THOMPSON: ANTIQUES BOUGHT AND SOLD
Emma Wesley
Acrylic on board, 1249 x 805mm (49¹/₈ x 31³/₄")

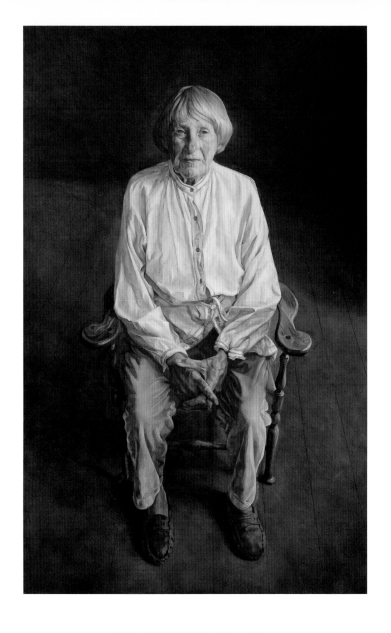

MARY SPENCER-WATSON, SCULPTOR
Toby Wiggins
Oil on canvas, 1452 x 917mm (57$\frac{1}{8}$ x 36$\frac{1}{8}$")

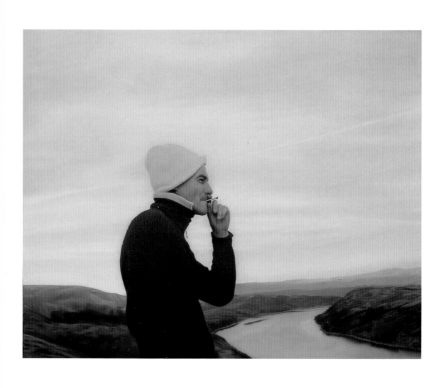

DOUG
Craig Wylie
Oil on canvas, 889 x 1190mm (35 x 46⁷/₈")

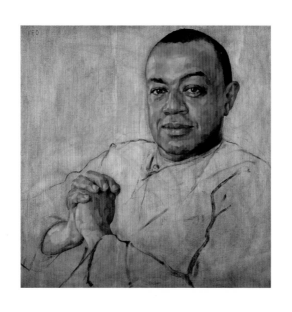

RT HON PAUL BOATENG
Jonathan Yeo
Oil on canvas, 764 x 764mm (30 x 30")

BP TRAVEL AWARD

'The Travel Award provides an opportunity to reflect on our evolving world' says Ulyana Gumeniuk who chose Russia and Ukraine because they are undergoing radical political, economic, social and cultural changes.

MURAL PAINTING

Ulyana began by looking at the classical tradition of mural painting by studying at St Petersburg Academy of Arts, founded by Catherine the Great in the eighteenth century. 'It was inspiring to be surrounded by such marvellous works created by former students. I was assigned an assistant who took me through every stage of the process: preparing the materials, transferring the drawing, building layers of colour and finishing.'

Her second project was a mural commission from the priest for the Orthodox Ukrainian church in Podil – 'a great honour as traditionally in the Orthodox Church women were not allowed to paint religious icons.

'I chose to follow the traditions of the famous icon painters: to fast for three days, then go to confession, stand for hours praying, carry out sacred rights, and fast for the entire period of painting, one month. The priest gave me written prayers to consider while I worked and blessed me. Often I would be locked inside the church until about 9pm or even stay in its sixteenth-century crypt. It was an incredible spiritual experience.

'I developed my own traditional approach: the faces are more stylised than realistic.'

LOCAL PORTRAITS

'Finally I travelled to small villages in Ukraine and Russia where I met a wide variety of people from ministers in government to children and the aspiring next generation.' They had all seen huge changes and have struggled to adjust, experiencing varying degrees of pain and disillusionment. Ulyana selected sixteen people to sit for her, each sitting for up to two hours while she interviewed and painted them. Here are three of the portraits with extracts from their interviews.

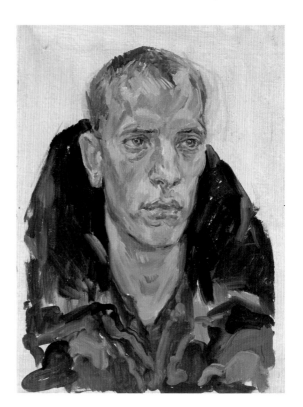

RUSLAN
Ulyana Gumeniuk
Oil on canvas,
350 x 260mm
(13³/₄ x 10¹/₄")

RUSLAN

'I had a dream like every young boy to join the army –
to become a real man. When I got to the army, my
image of it burst like a soap bubble. There were no rules,
no laws: just sheer brutal force . . . I was framed. When
our unit was disbanded, we were not issued with leave
passes: we were just told to go. Suddenly the com-
mission arrived and locked me up for desertion.

'I had many brutal experiences including being put
in a metal boxroom as wide as my shoulders and hav-
ing chlorine poured over me. It was only thanks to my
talent, drawing, that I survived and was appreciated . .
. Some good people helped me get a job working with
wood. Now we have a carpentry shop.'

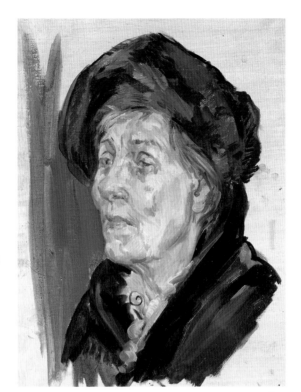

KONDRATIERA
VALERIA YIURIEVNA
Ulyana Gumeniuk
Oil on canvas,
350 x 260mm
(13³/₄ x 10¹/₄")

KONDRATIERA VALERIA YIURIEVNA

'My passion is a love of reading, which was given to
me by my grandmother. Her husband's cousin was the
famous writer Leonid Andreev. She was a sensitive, no-
ble human being: a source of hope and support in the
days of dark thoughts and doubts. It was due to the love
of books, and later on in life, to the love of theatre that
I have experienced the brightest moments of the joy of
being. Although the memories mix with a constant feel-
ing of the loss of something piercingly close . . .

'I perceive openly and with excitement, everything
that is related to true art. It takes my mind off all that is
negative. Oh, those moments . . . my joy, my hope, my
sanctuary, all sank into darkness – I became blind.'

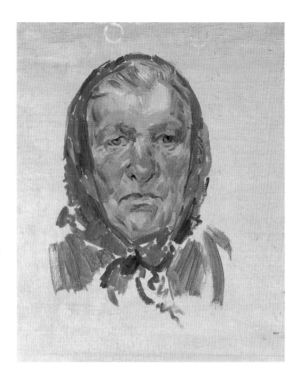

MARIA KUHARENKO
Ulyana Gumeniuk
Oil on canvas,
275 x 235mm
(10⁷/₈ x 9¹/₄")

MARIA KUHARENKO

'Oh dear, oh dear, this year's tomatoes! I spent so much money on buying seedlings and they all went bad.

'And why have you no children yet? It's no good, no family, no children – that's out of order! Get on with it, you shouldn't live like that, children are a "must" . . .

'We got a new cow recently and it's a young one. Now we are really struggling: we have six pigs. But how can I make money or live when to feed a pig costs 800gr [£80] but to sell it 600gr [£60]?

'You work and you work and you work! First planting potatoes and vegetables, then it's weeding and picking potatoes and beetroot, then it's winter and planting again [done by hand]. I haven't been down to the river [twenty minutes away] this summer more than twice . . . Such hard work, so, so much hard work here.'

ACKNOWLEDGEMENTS

My thanks go to the artists who entered, to those selected for the exhibition and to the four short-listed artists. The selection was made possible by an exemplary set of judges and I would like to acknowledge the diligence and perception of Susan Ferleger Brades, John Keane, Trevor Phillips and Des Violaris.

I should also like to offer special thanks to Blake Morrison for his memorable essay, to Caroline Brooke Johnson, Anne Sørensen and Ruth Müller-Wirth for work on this catalogue, and to Kathleen Soriano for co-ordinating the 2004 BP Portrait Award exhibition. Pim Baxter, John Haywood, Beatrice Hosegood, Rosie Wilson, Sarah Howgate, Hazel Sutherland, Ian Gardner, Jan Cullen, Liz Rideal and many other colleagues in the Gallery have contributed wonderfully and I am very grateful to them.

Finally, I would like to give particular thanks to BP for their continuing support of the Portrait Award. BP is a wonderful partner and we are very pleased to have the much valued support from Lord Browne and his colleagues.

SANDY NAIRNE
Director, National Portrait Gallery

The National Portrait Gallery would like to thank all the exhibiting artists who submitted a proposal for the BP Travel Award 2003 and the three judges, who interviewed the short-listed artists. The judges were Des Violaris, Business Adviser for BP, and the National Portrait Gallery's Contemporary Curator Sarah Howgate and Art Education Officer Liz Rideal.

Ulyana Gumeniuk would like to thank Gavin Starks for his support with the BP Travel Award 2003.

The full interviews with all the subjects painted by Ulyana Gumeniuk are available on her website at www.ulyanagumeniuk.com

INDEX